Copyright © 2016 by Ken Schneider

All rights reserved. No part of this publication may be reproduced, distributed, or transmitted in any form or by any means, including photocopying, recording, or other electronic or mechanical methods, without the prior written permission of the publisher, except in the case of brief quotations embodied in critical reviews and certain other noncommercial uses permitted by copyright law.

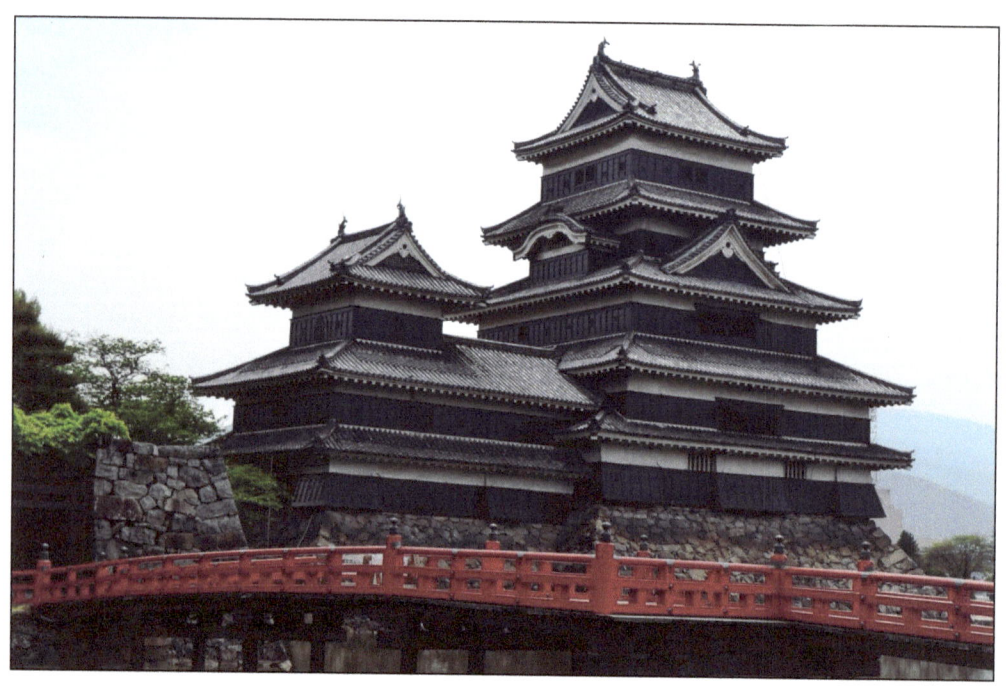

Matsumoto Castle 松本城

Nagano Prefecture 長野県

Heianjinguu

Kyoto

平安神宮

京都

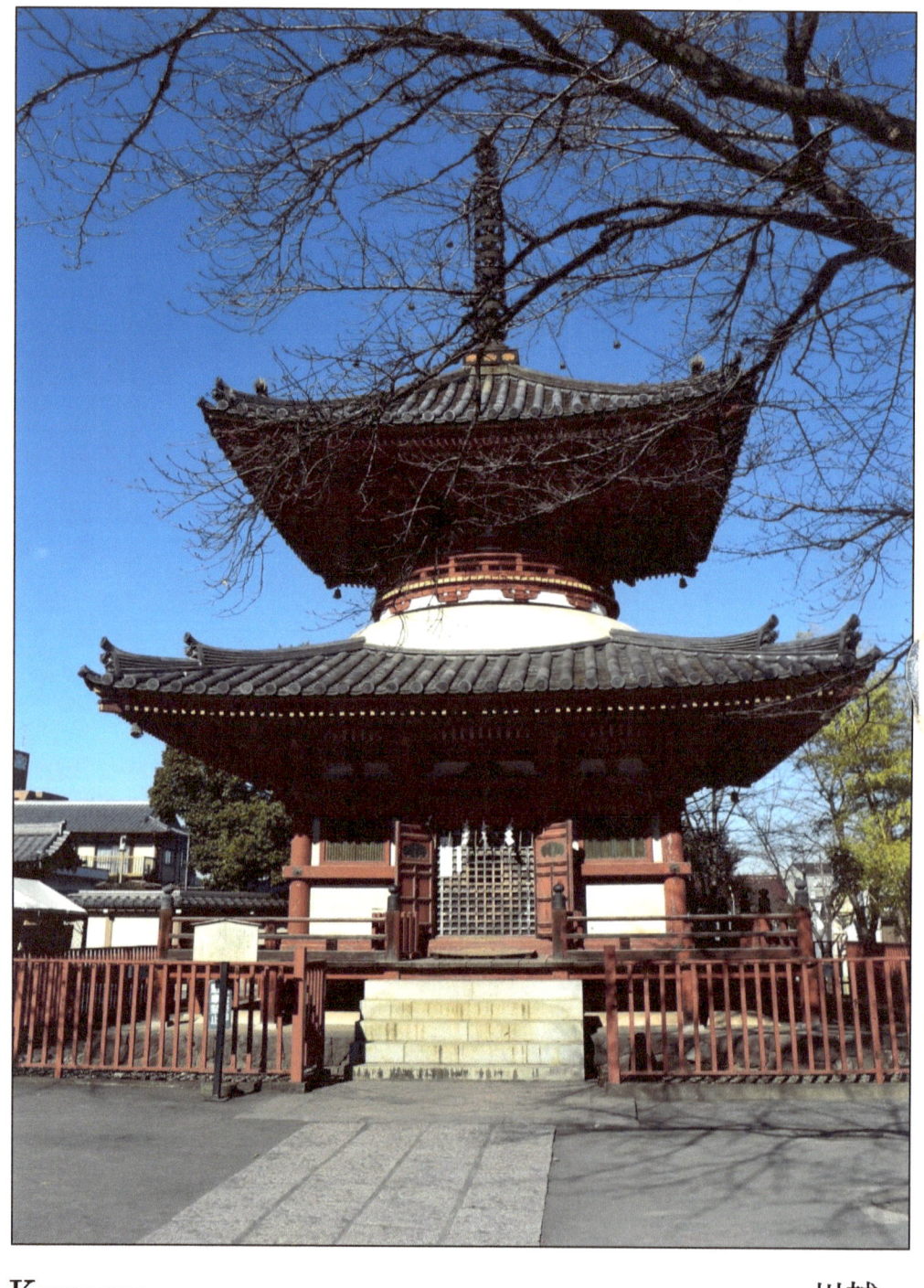

Kawagoe 川越

Saitama Prefecture 埼玉県

Kobe 神戸

Meriken Park

Kobe

メリケンパーク

神戸

Ise Shrine 伊勢神宮

Mie Prefecture 三重県

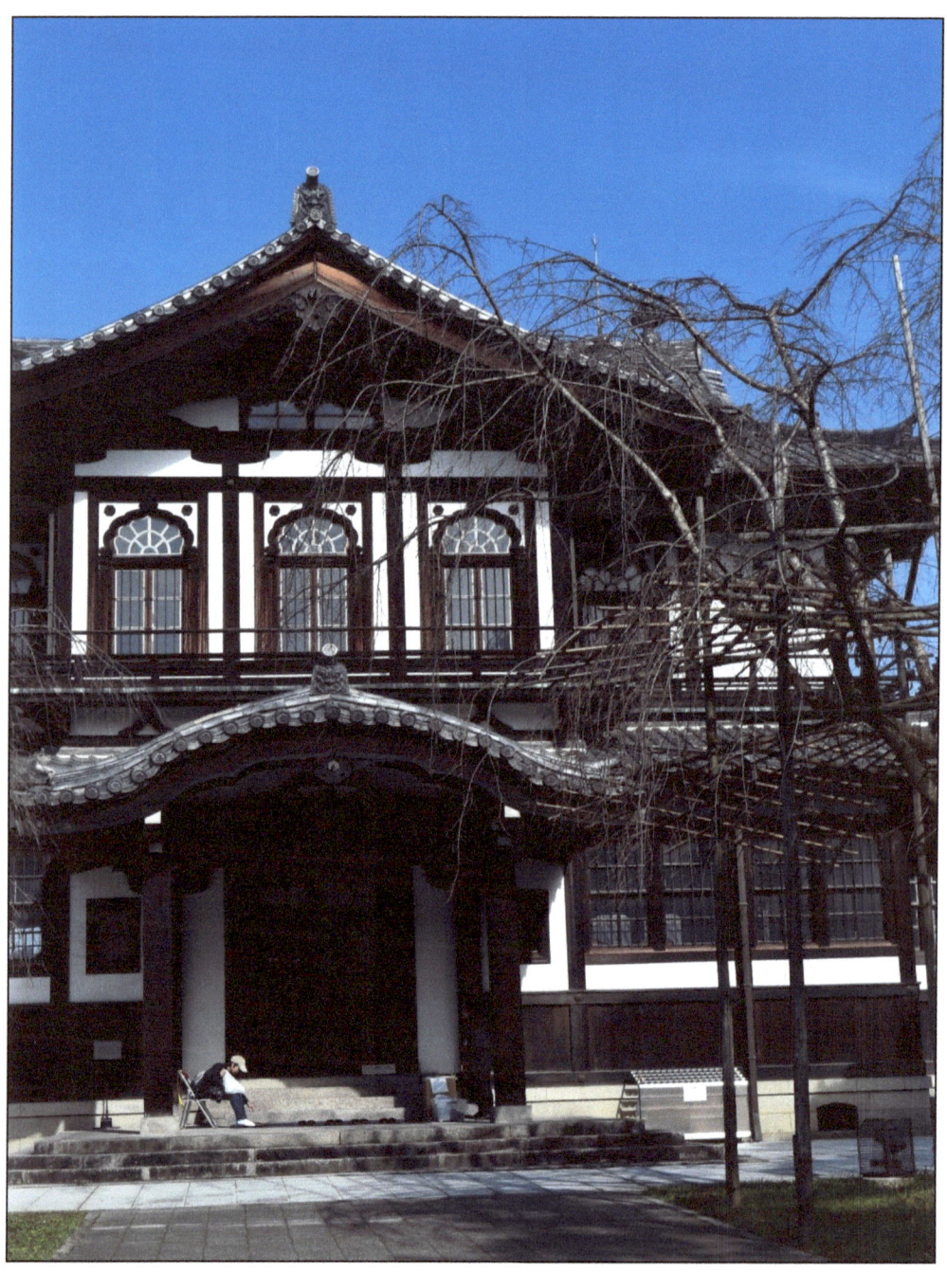

Nara National Museum 奈良国立博物館

Nara Prefecture 奈良県

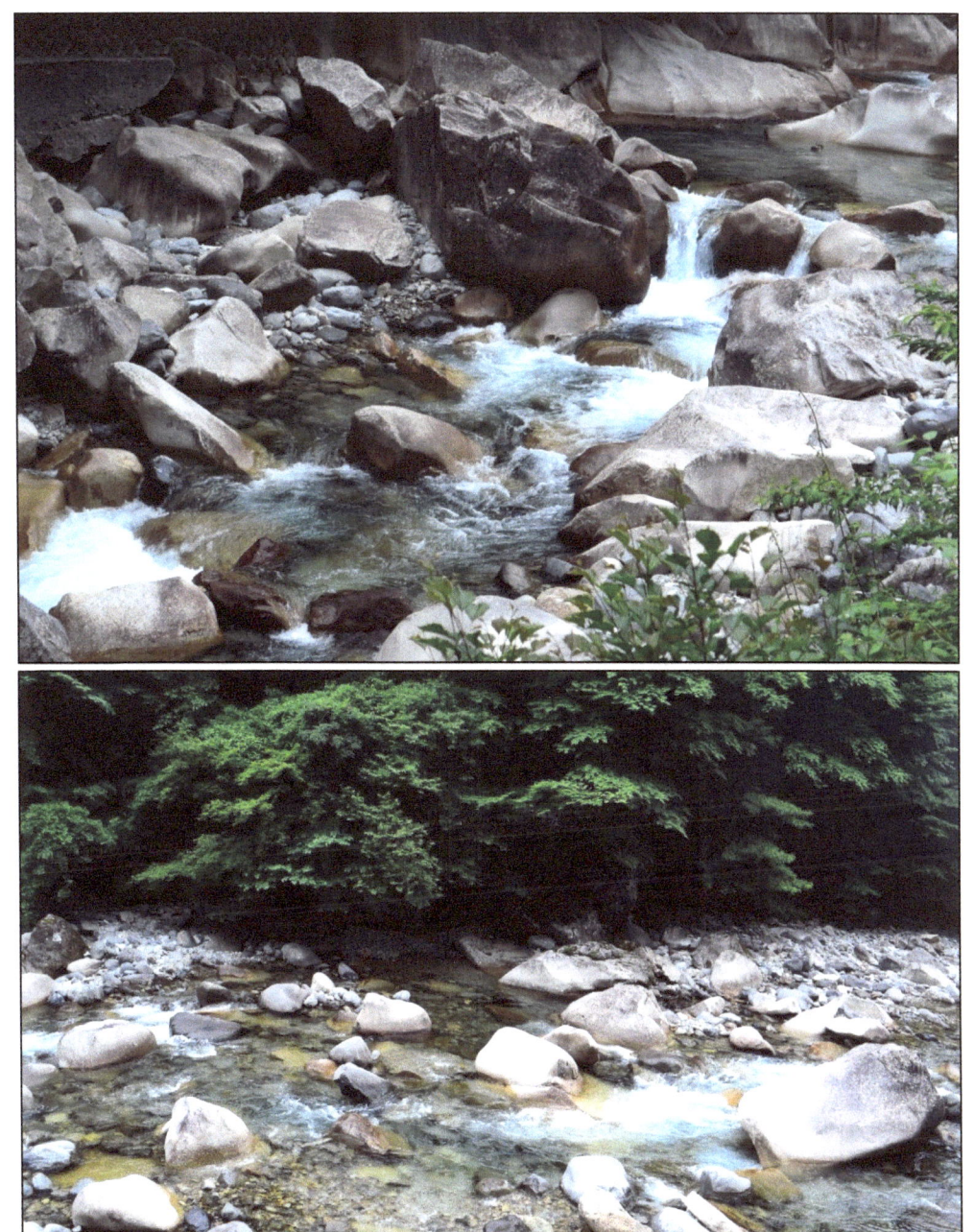

Adera Valley 阿寺渓谷

Nagano Prefecture 長野県

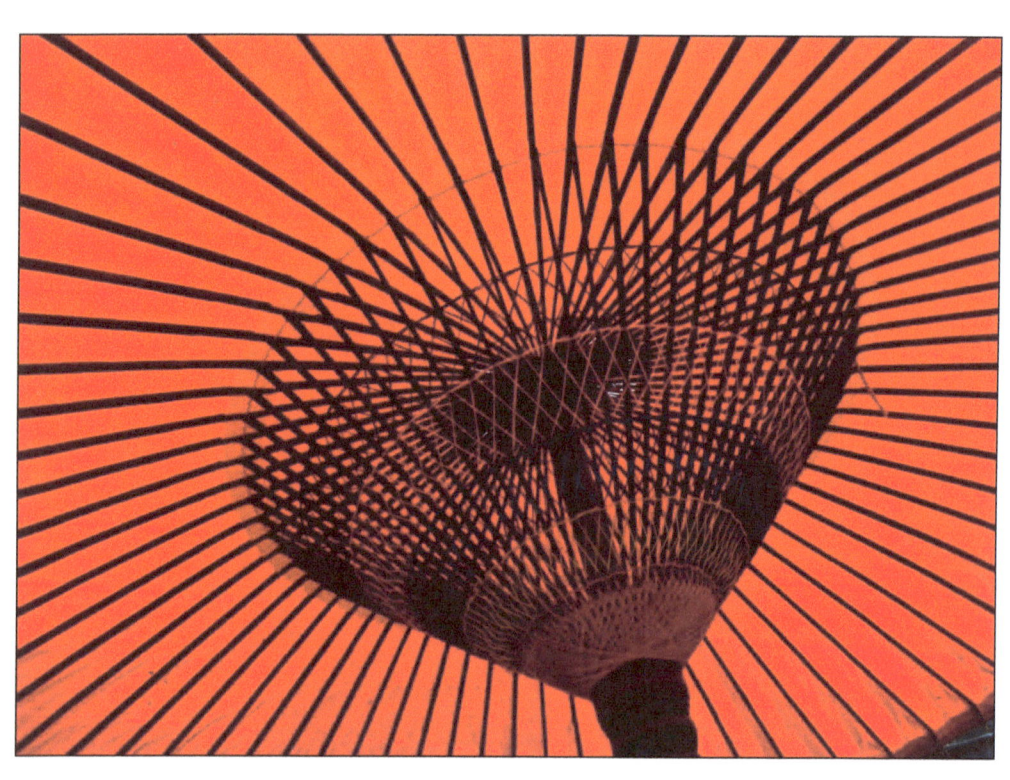

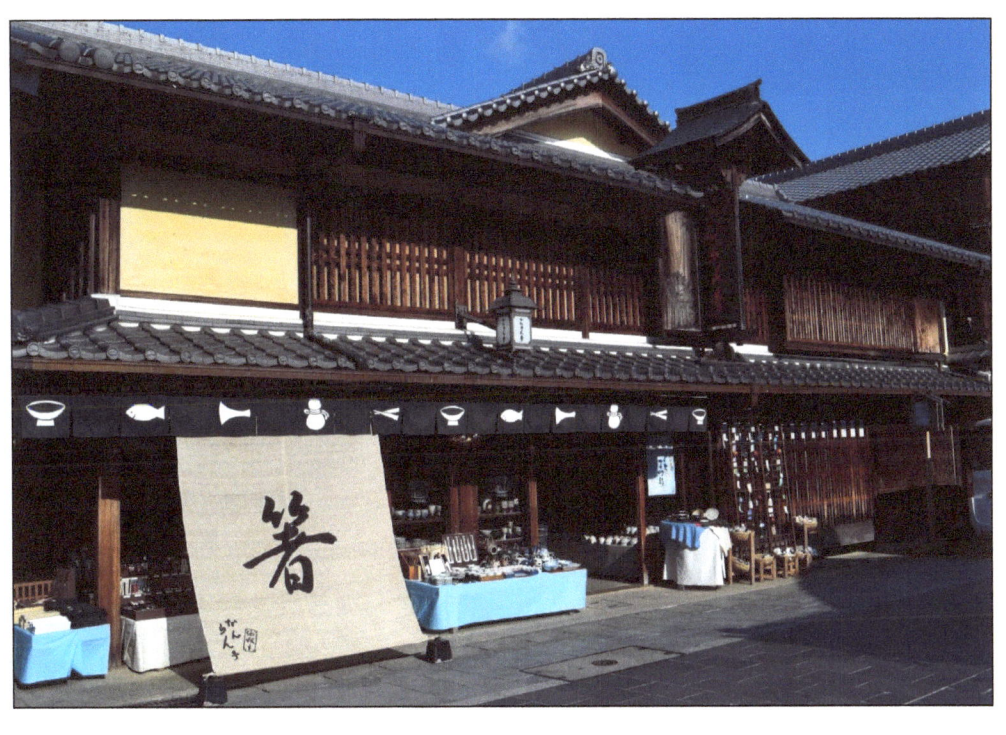

Okage-yokocho Street　　　　　おかげ横丁

Mie Prefecture　　　　　　　　三重県

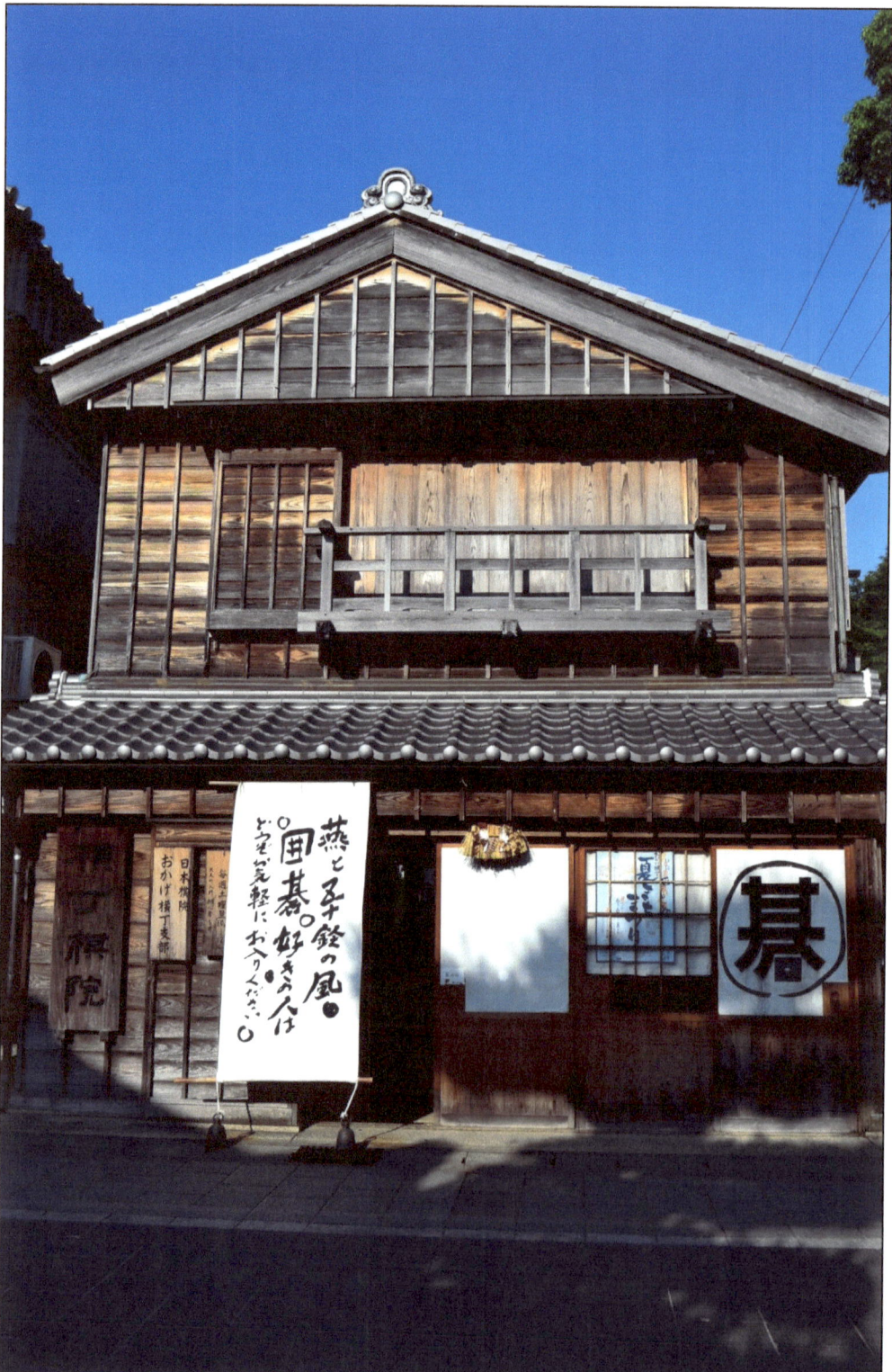

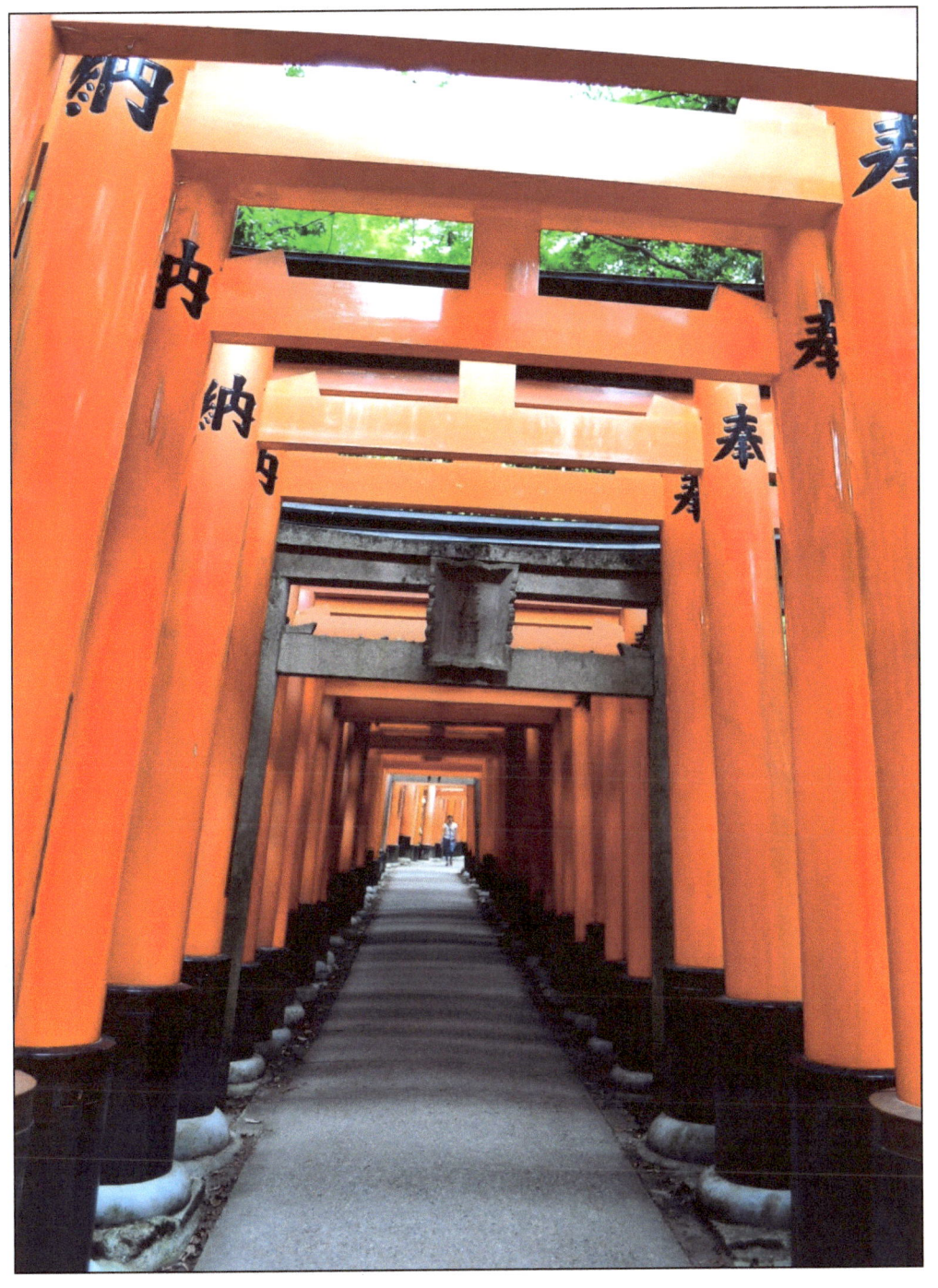

Fushimi-inari Shrine 伏見稲荷大社

Kyoto 京都

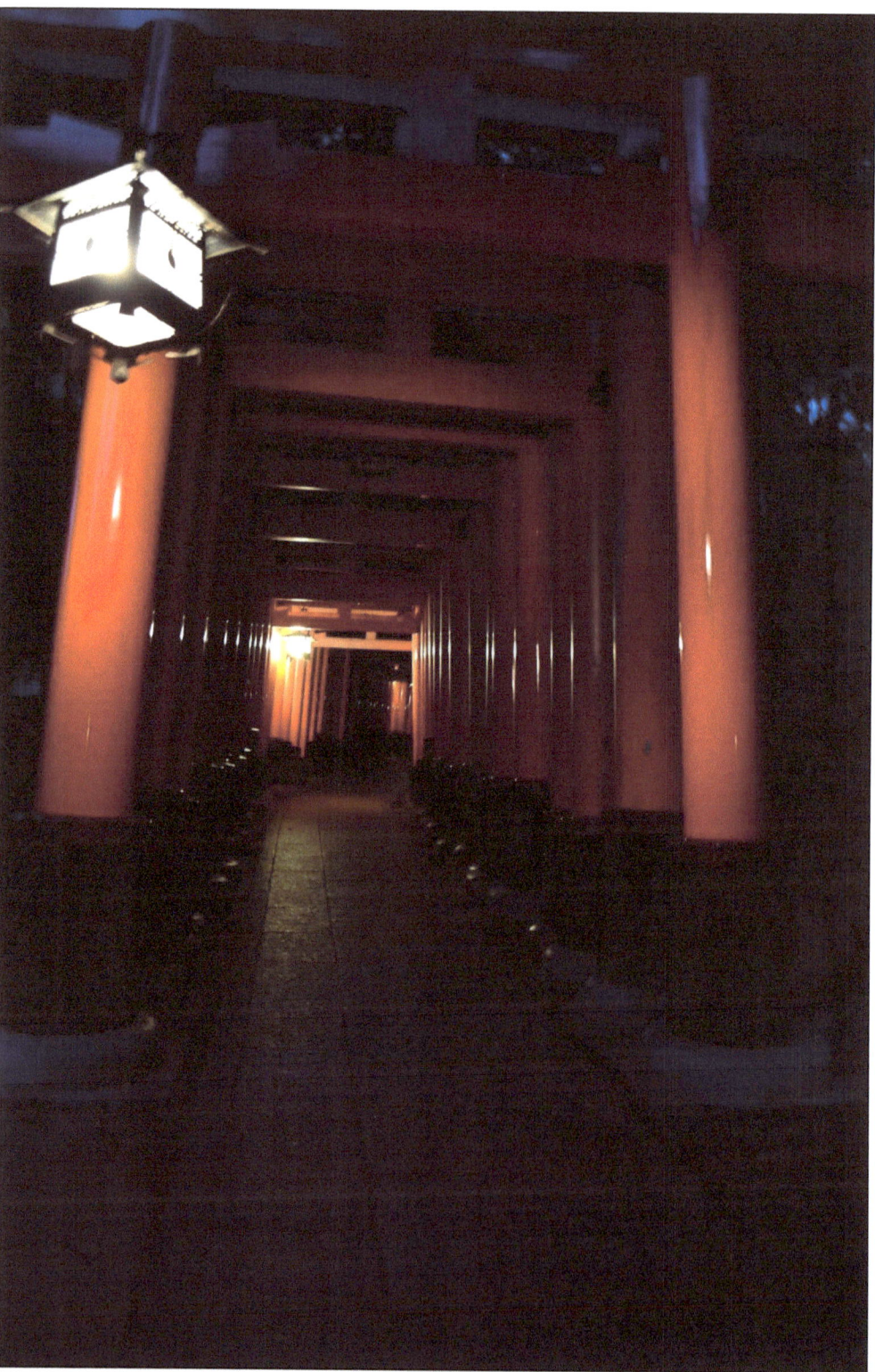

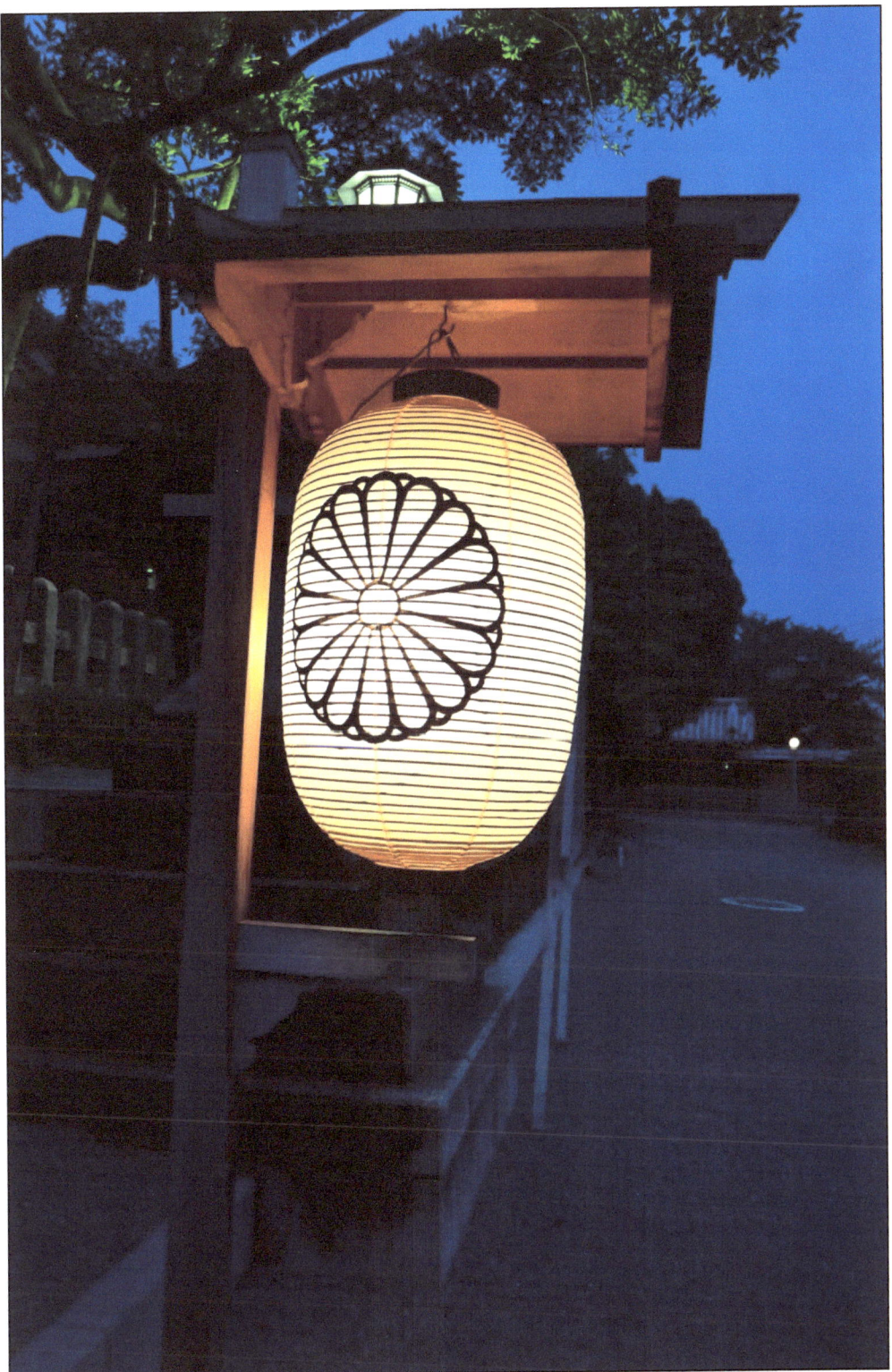

Fushimi-inari Shrine

Kyoto

伏見稲荷大社

京都

Mount Osore

Aomori Prefecture

恐山

青森県

Magome-juku 馬籠宿

Gifu Prefecture 岐阜県

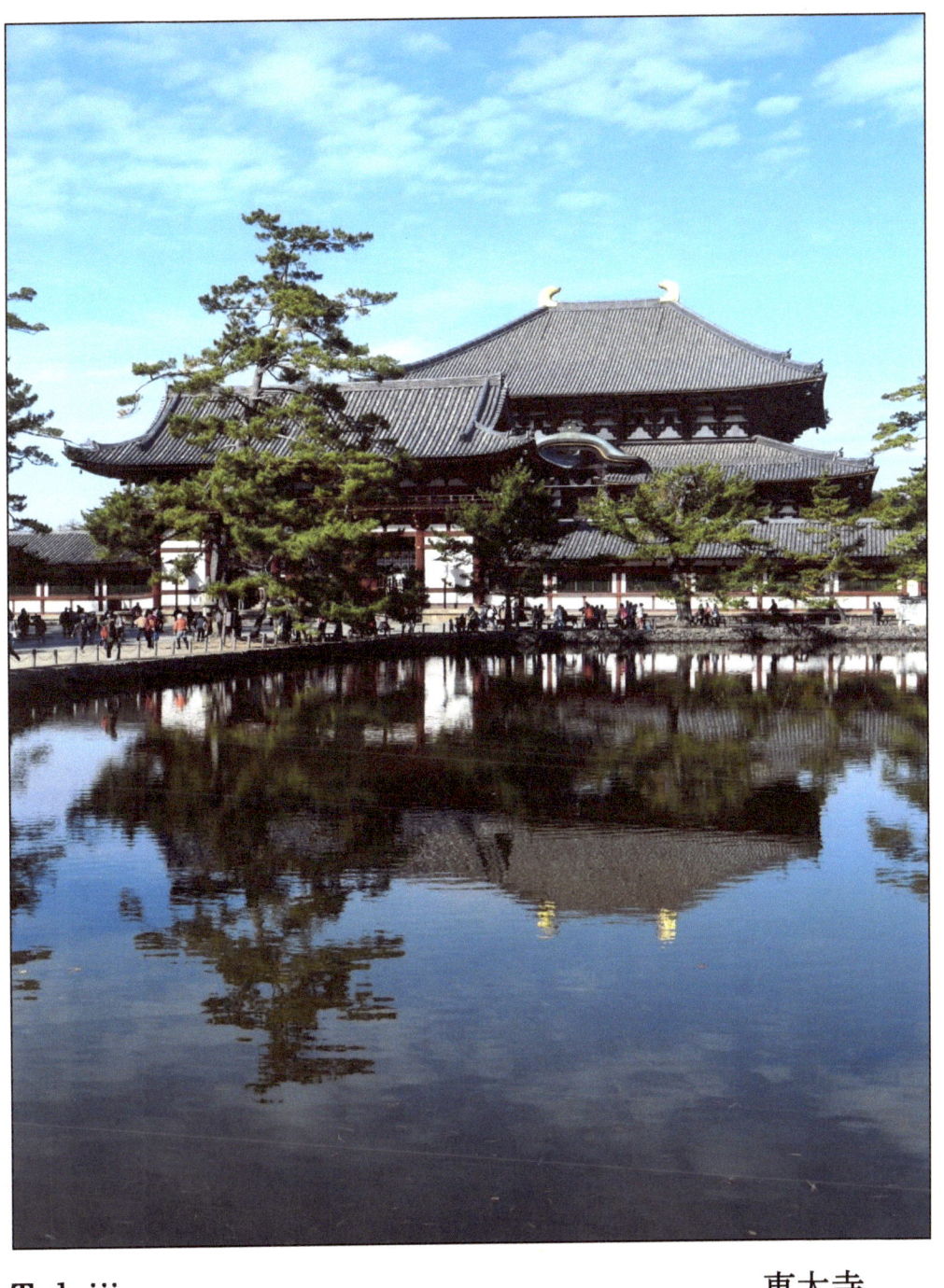

Todaiji　　　　　　　　　　　　　　　東大寺

Nara Prefecture　　　　　　　　　　　奈良県

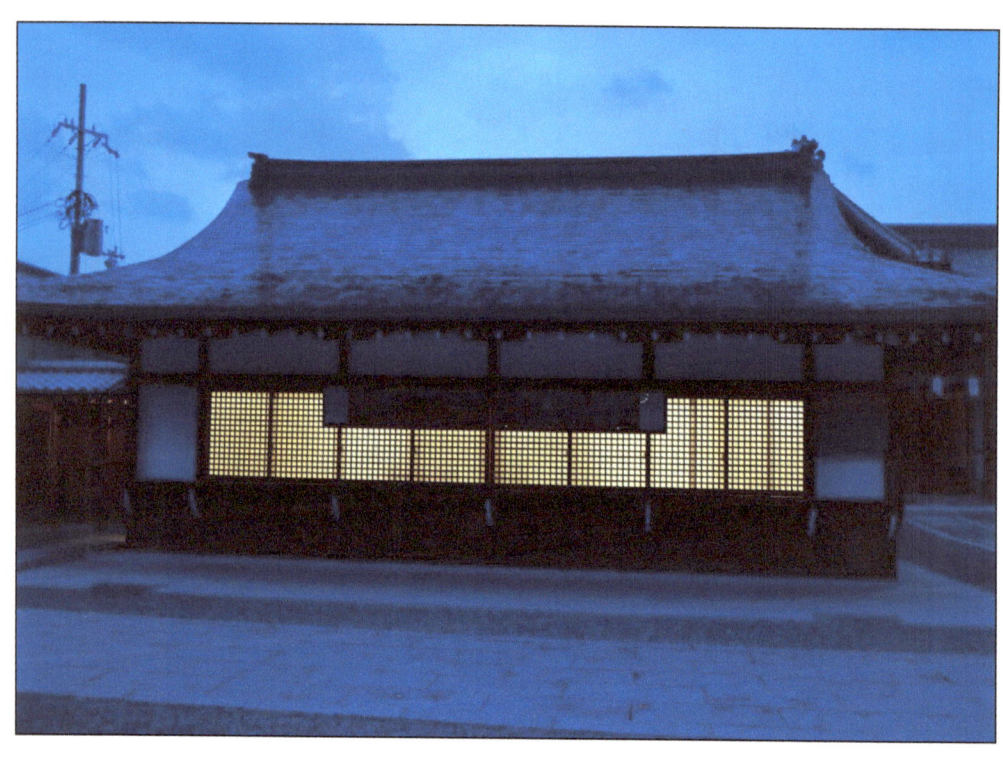

Horyuji; Kofukuji

Nara Prefecture

法隆寺;興福寺

奈良県

Odawara Castle 小田原城

Kanagawa Prefecture 神奈川県

Mount Takao

Tokyo

高尾山

東京都

Mount Takao

Tokyo

高尾山

東京都

Heijokyo 平城京

Nara Prefecture 奈良県

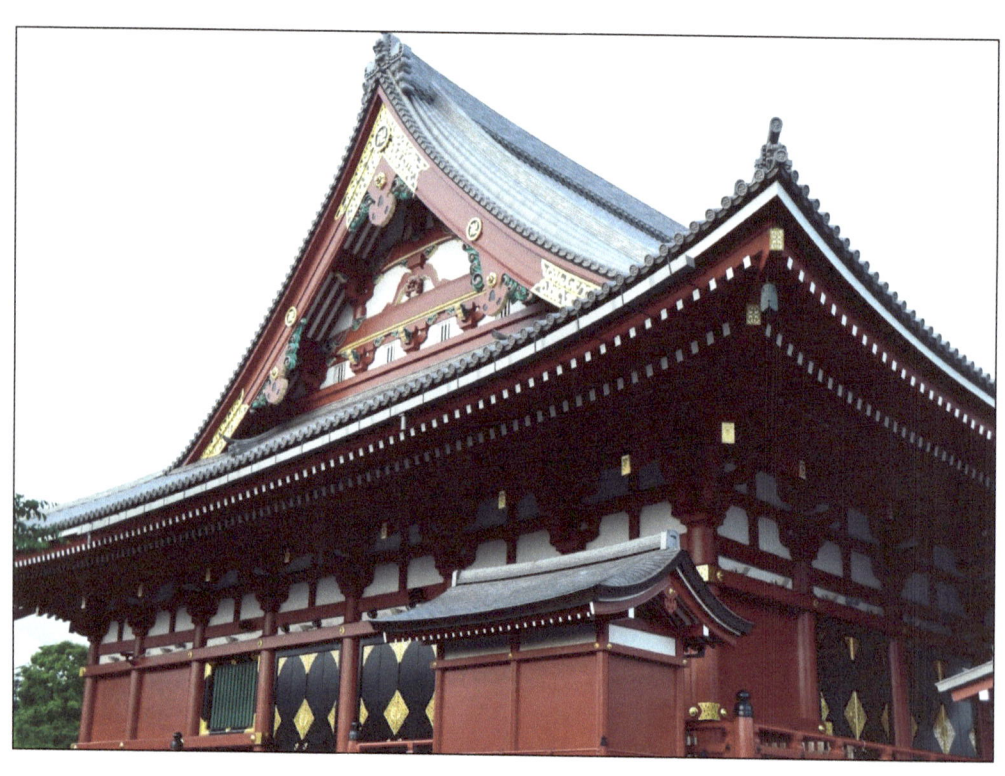

Asakusa 浅草

Tokyo 東京都

Asakusa 浅草

Tokyo 東京

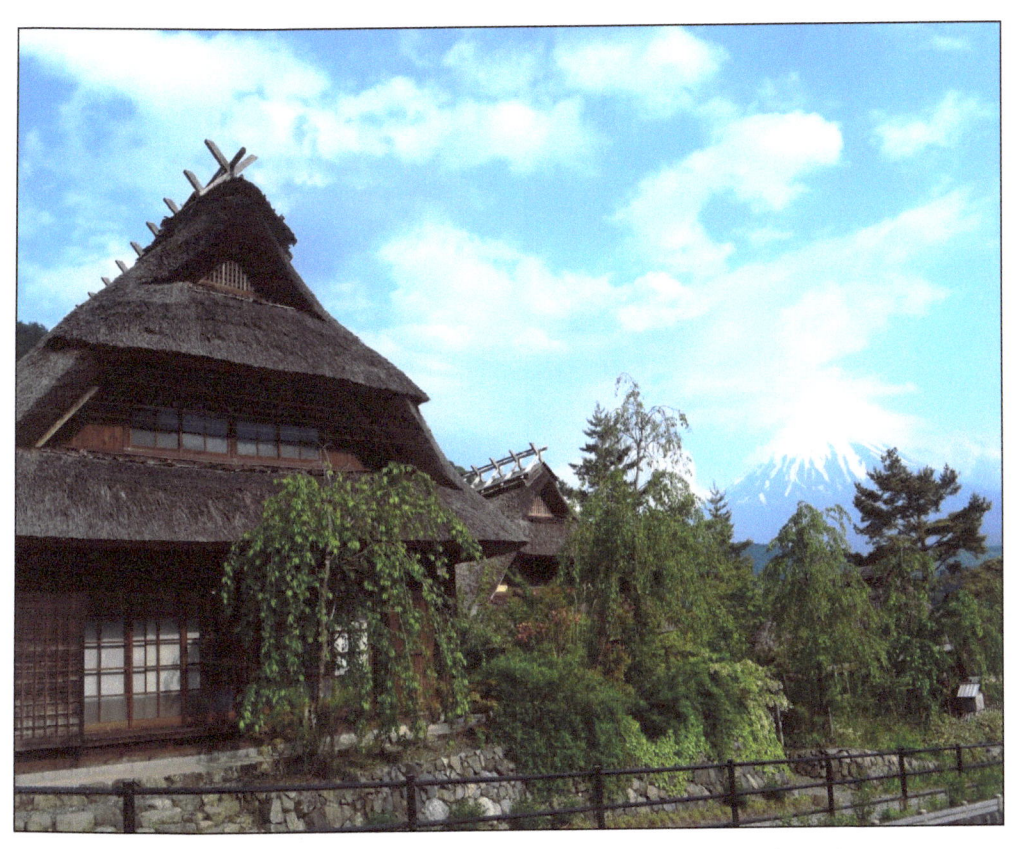

Mount Fuji

Yamanashi Prefecture

富士山

山梨県

Fushimi-inari Shrine 伏見稲荷大社

Kyoto 京都

www.ingramcontent.com/pod-product-compliance
Lightning Source LLC
Chambersburg PA
CBHW041119180526
45172CB00001B/323